Copyright 2018
by Virgil Suárez

No part of this book shall be used without
permission from the author.
For permissions please contact
Virgil Suárez
vsuarez666@aol.com

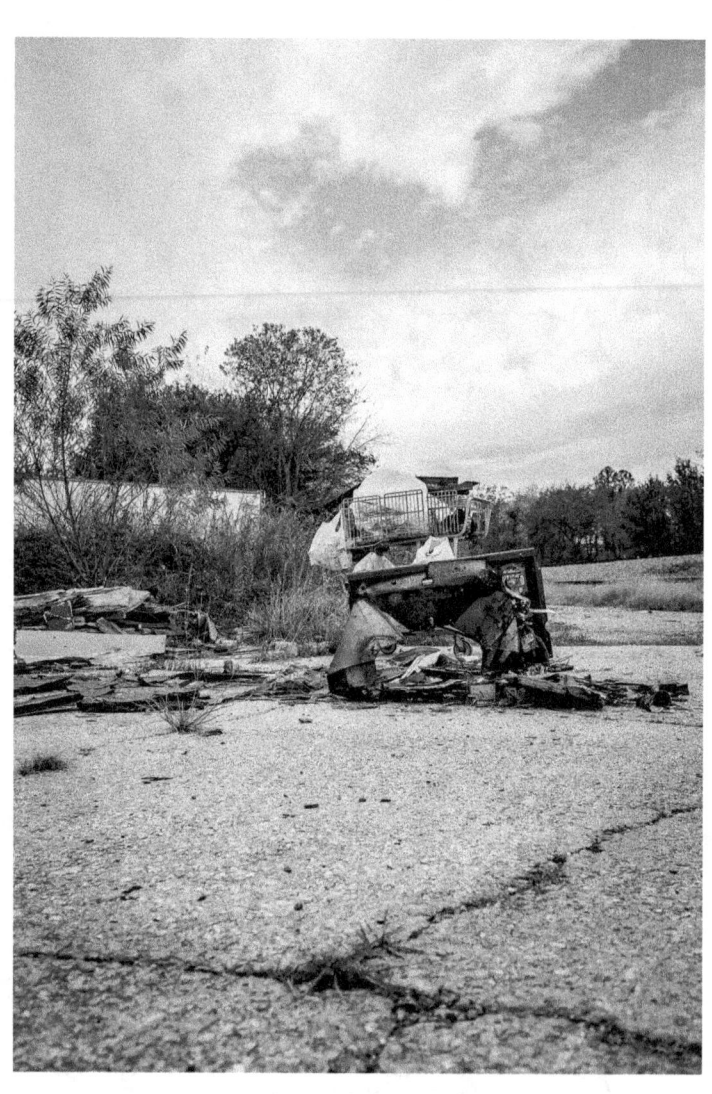

ERASURE

Nothing stays the same. Everything changes. Time takes no prisoners. I've been on the road too long, driving my Yamaha V-Star 1100 Classic up and down the Blue Highways of these less United States, and sometimes over and across the border. What remains the same is the vast and disappearing landscapes of the old. The trash and refuse. The discarded. An endless sea of garbage that will take hundreds of years to bio degrade. The rest is the useless stuff we hoard, implements some one cut a finger making, broke a nail, or gouged an eye. The cheaper/faster mentality got the worse of us. It's a cowardly new technological world. No one hears the human voice drowning in the click-click of thumbs hitting the keyboard. The sun sets blood orange on the rear view mirror. The wind kicks up dust, sand, and dead insects into my eyes and teeth. A bitter reckoning of no longer feeling at home anywhere. The body aches from whipping on the miles. The images and words gathered here are keepsakes of moments spent trying to find meaning and composure. A perfect respite for the imagination. On the road nobody knows your name. Nobody cares. The hour is late and the angst is deep. These are the last consolation images, the bread crumbs picked up along the way in hopes not to forget the way back home. Perhaps the apocalypse has already come and gone. I could not tell you the difference. We are in it for the duration. We are in it for the duration or until the Earth's final shudder or the next big BANG.

Detritus is a reality of all the things discarded along the way. Everything stays the same, nothing changes when you find such precious road kill. Once upon a time there was meaning in the things we built and cared for. Now all that is behind us. Yes, it is getting late, dinner is almost on the table. Time to light that evening cigar and give birth to new demons. May you enjoy what's on the menu. Foraging should be as instinctive as taking your next breath, your next step. Enjoy the journey as you now know it. Take a big bite and don't forget to chew.

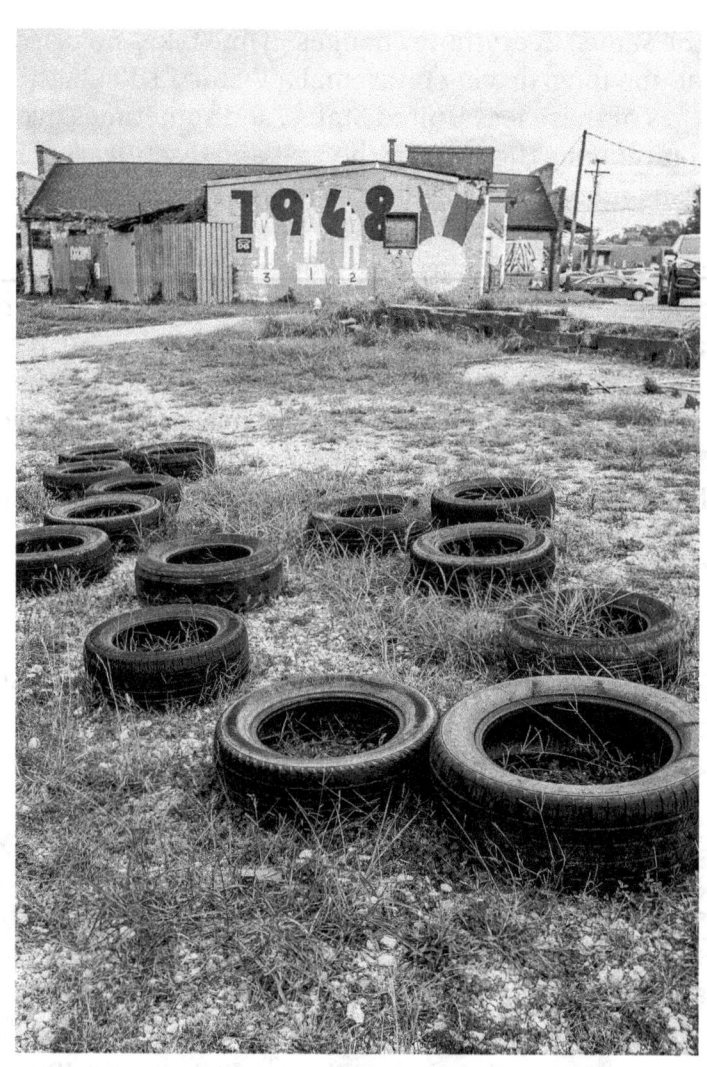

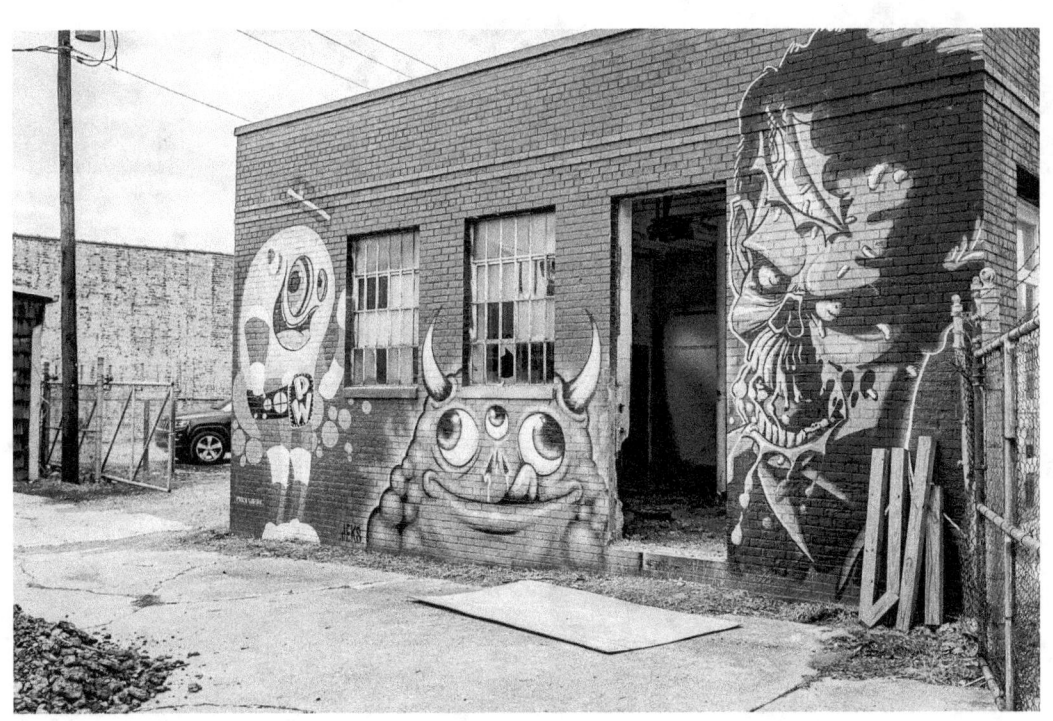

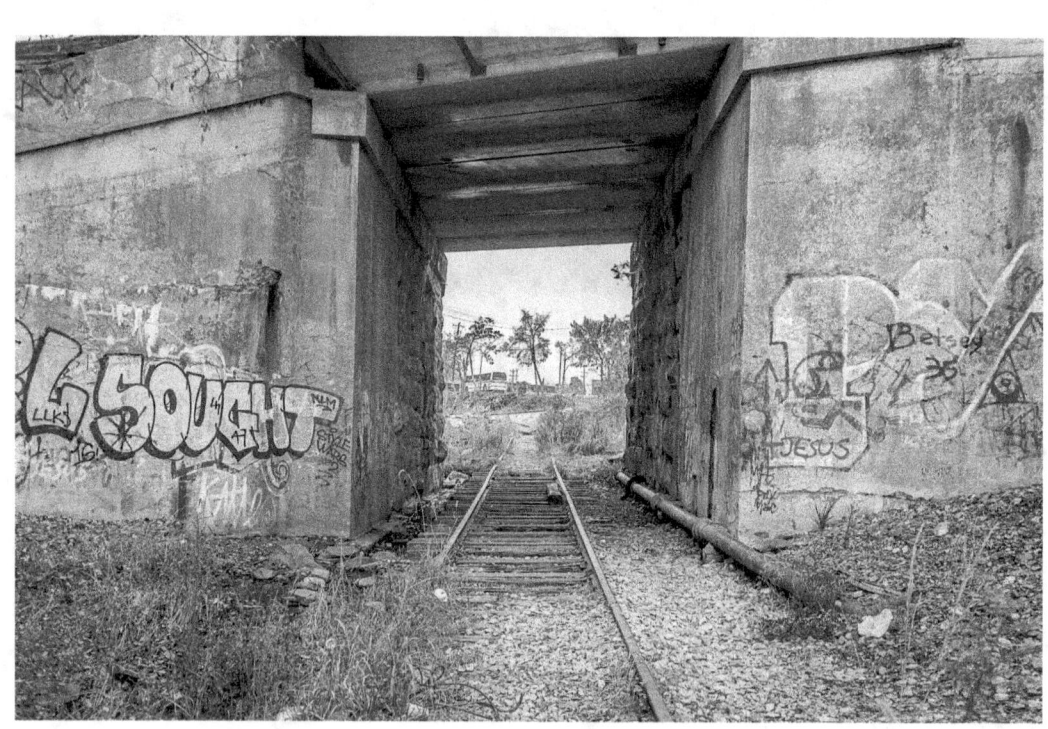

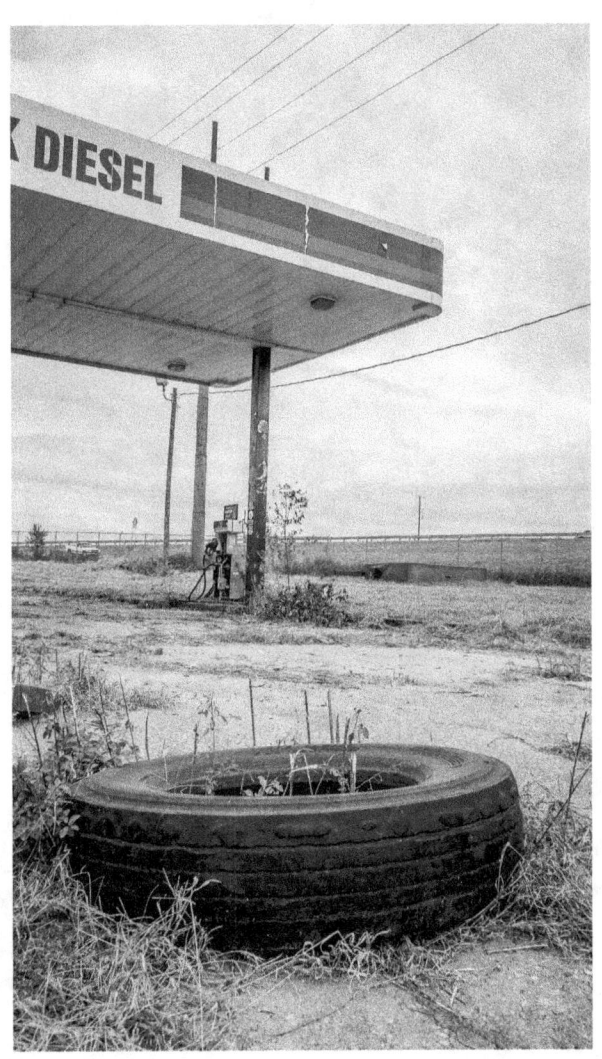

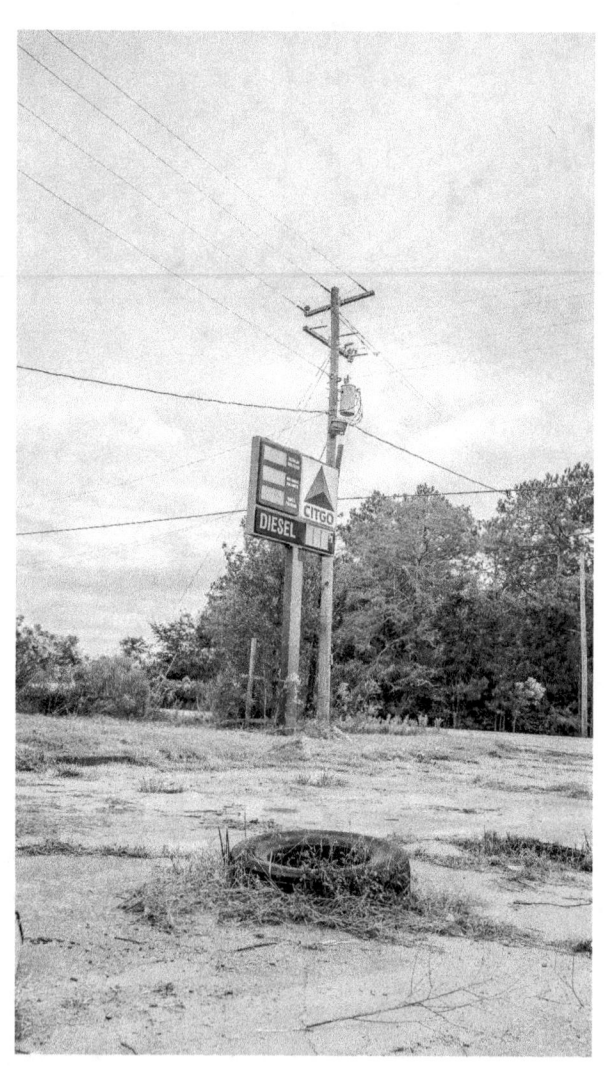

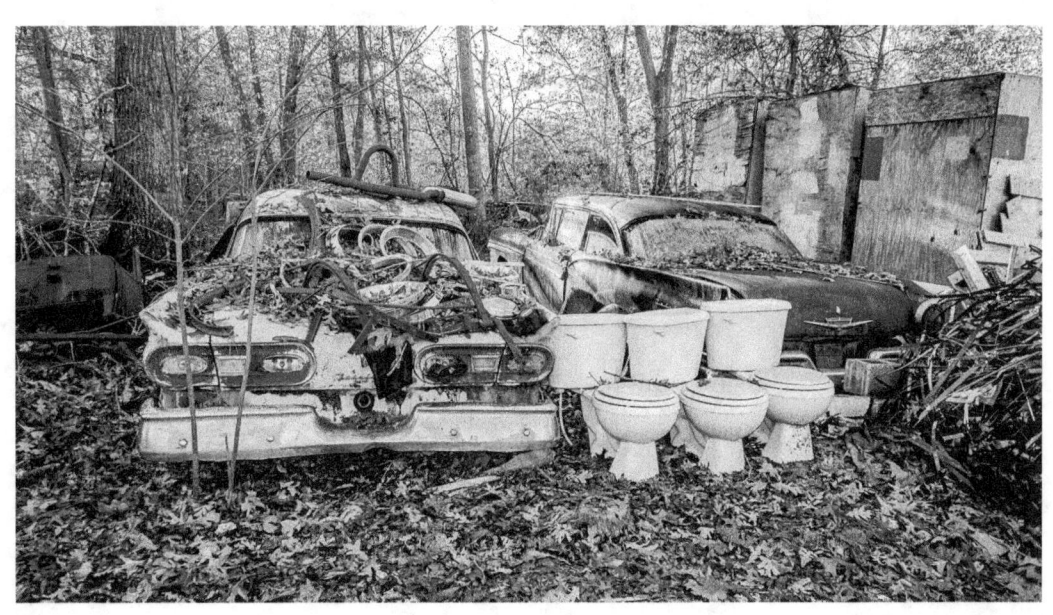

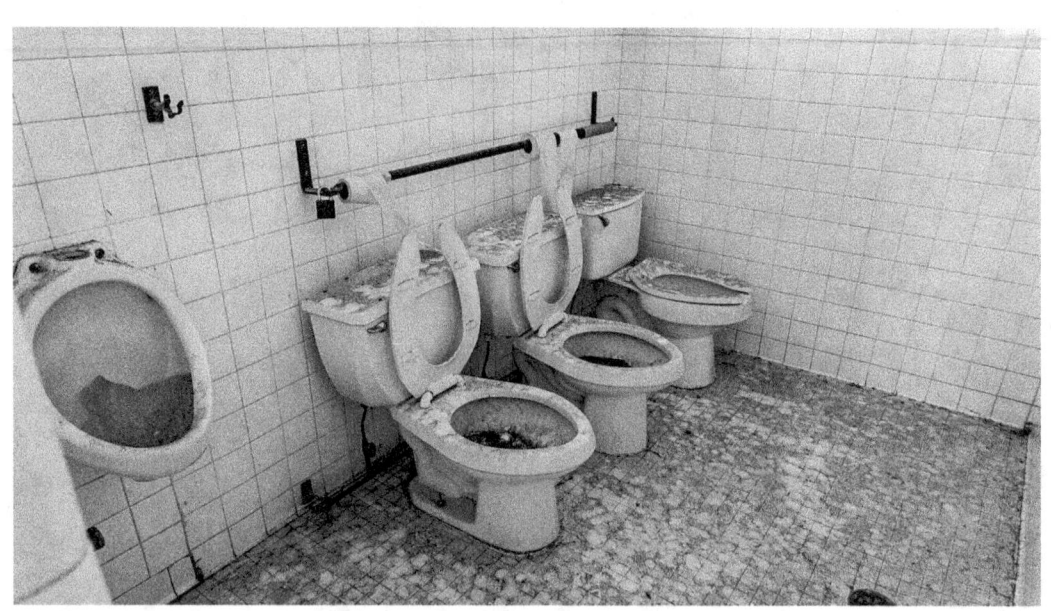

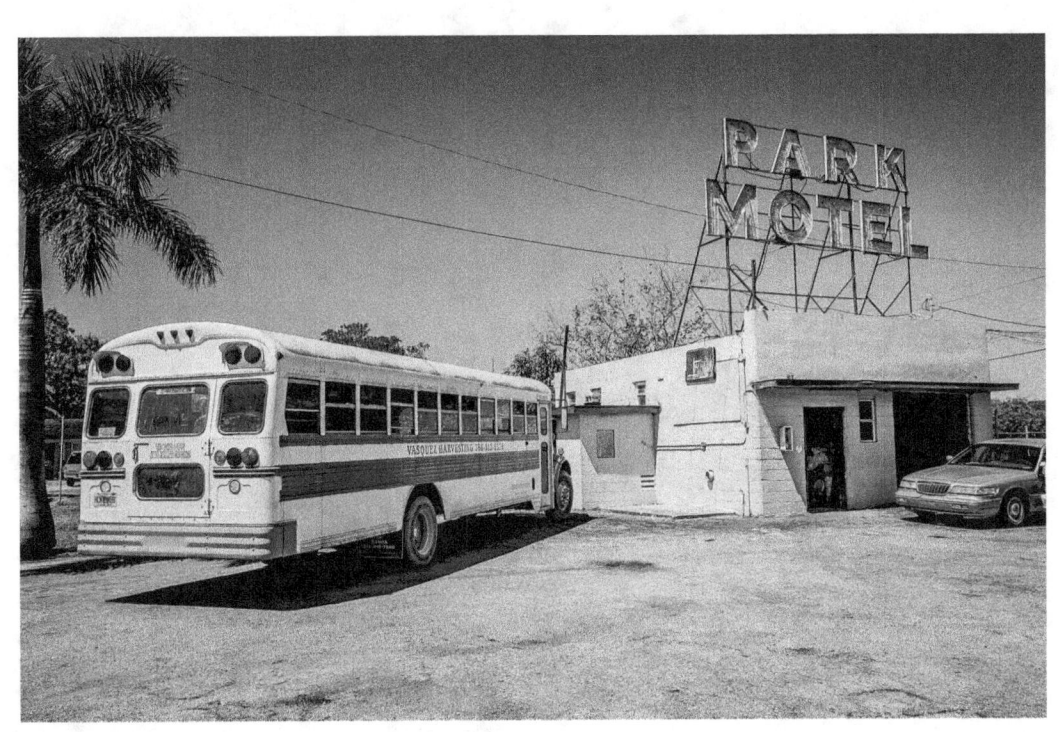

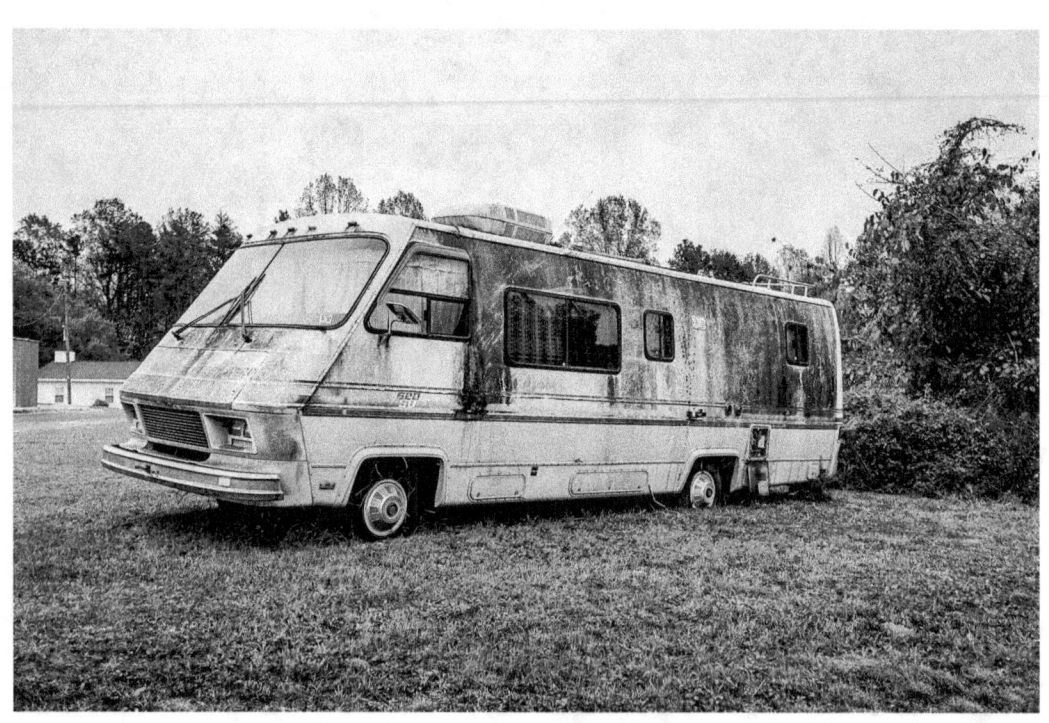

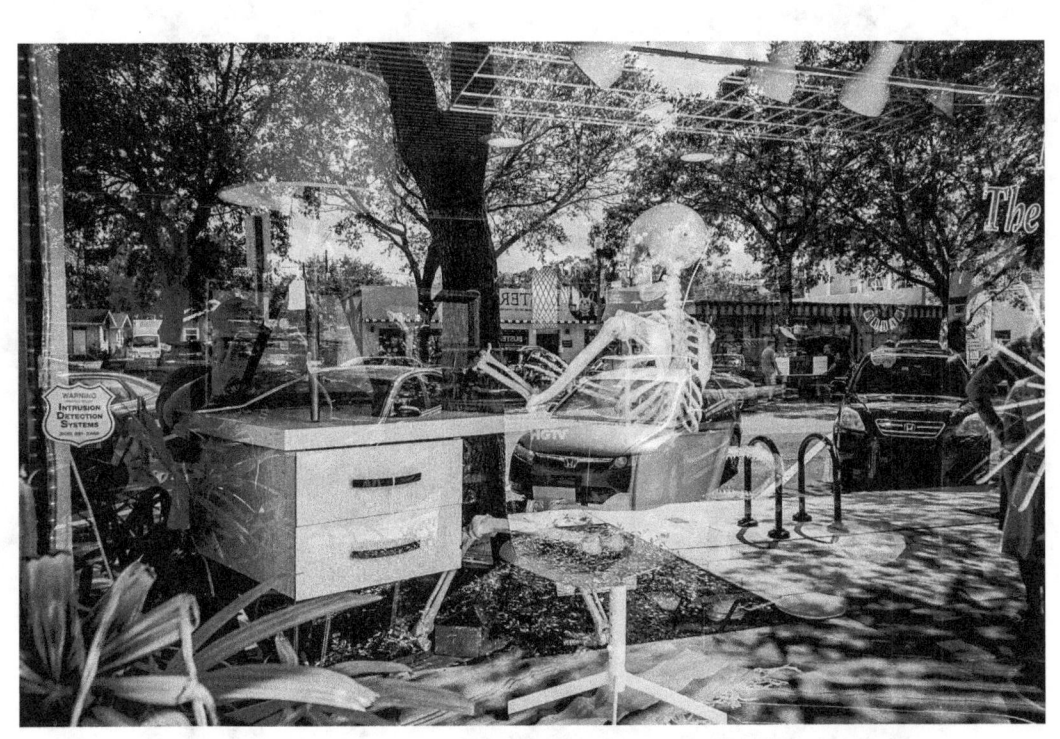

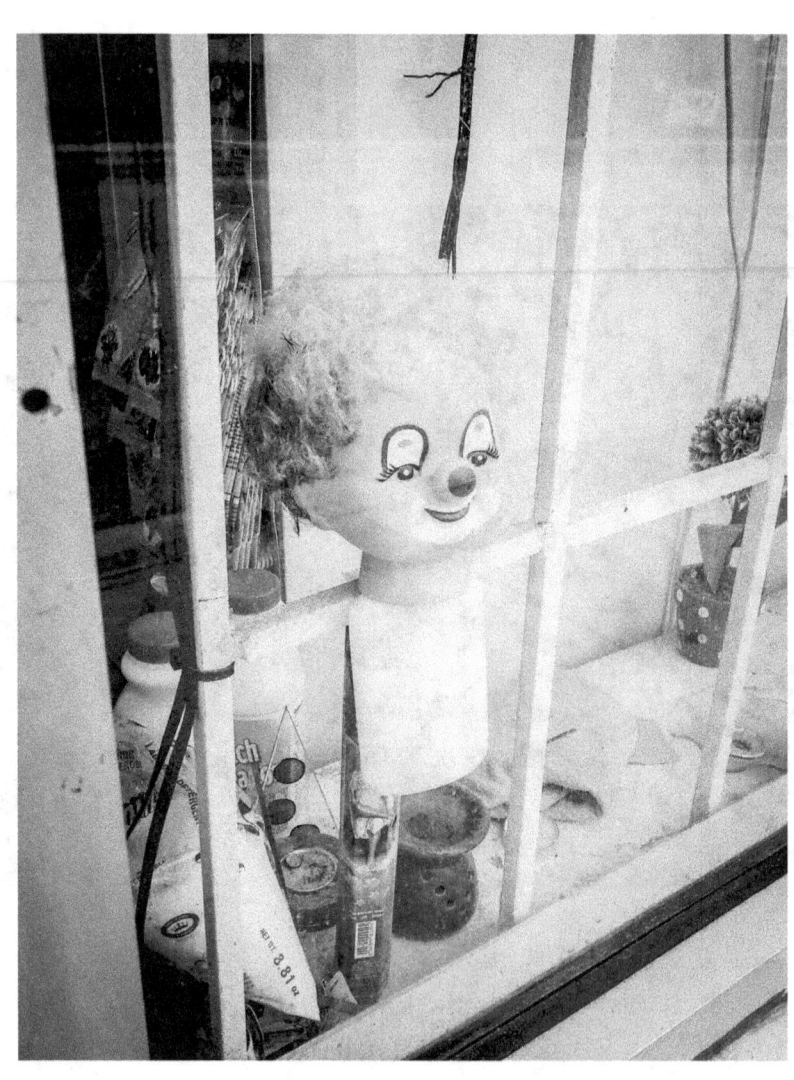

THE BEAUTIFUL LIGHT

Most of the world is disappearing.
One car at a time, one person.

My daughter's endocrinologist
Says it's a fresh canvas every hundred

Years, a new slate that continues
To repeat itself, yellowing all along.

A slow demise and sinuous flaccidity
To the flesh. Metal rusts. Organic

Material decays. We make time cringe
At will, but time doesn't seem to even

Want to linger in this pocket of marsh
Where a terrapin's snout disturbs a froth

Of duckweed and algae. Insects freeze
Inside the pages of an ancient book.

It's daylight savings again, here comes
That light that casts a shadow on the porch.

A bloody cardinal files its complaint
To the sun that the squirrels hoard

all the seed in the broken bird feeder.
On a desolate highway, a roof caves

In at the abandoned motel. A tile crushes
The rat. A nest of wasps is torn asunder.

That buzzing you hear is the light
Fighting back its inability to remember

We'd been here in this same room
Watching Hopper paint the billowed

Curtain. Outside the clouds drag themselves
Across the landscape again. They speak

a ruckus in eternal and yet momentary
sameness. They will be back tomorrow, right?

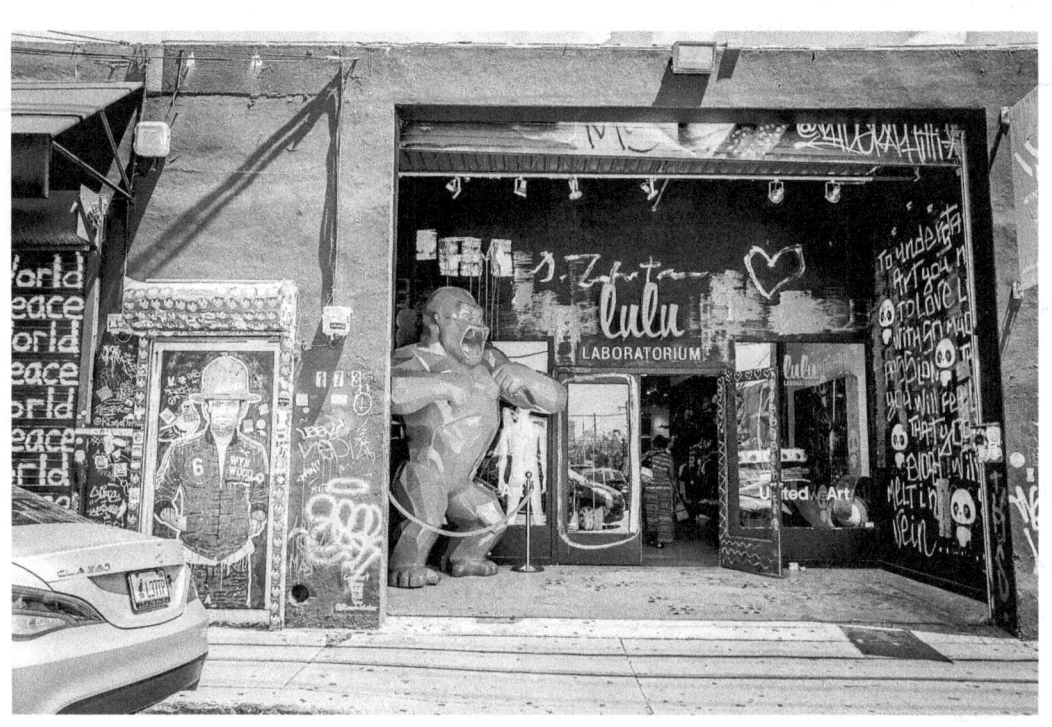

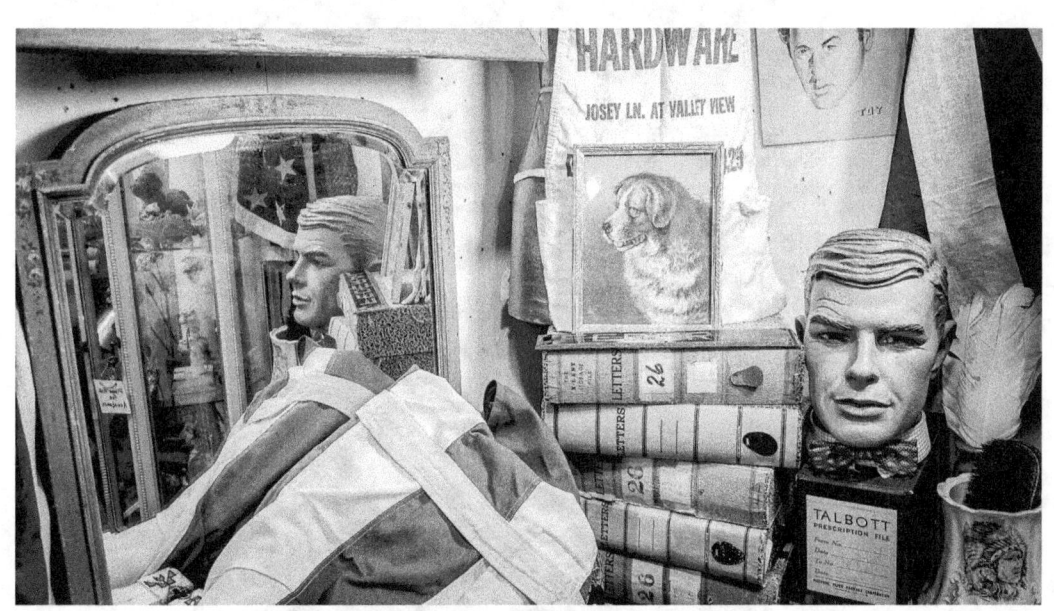

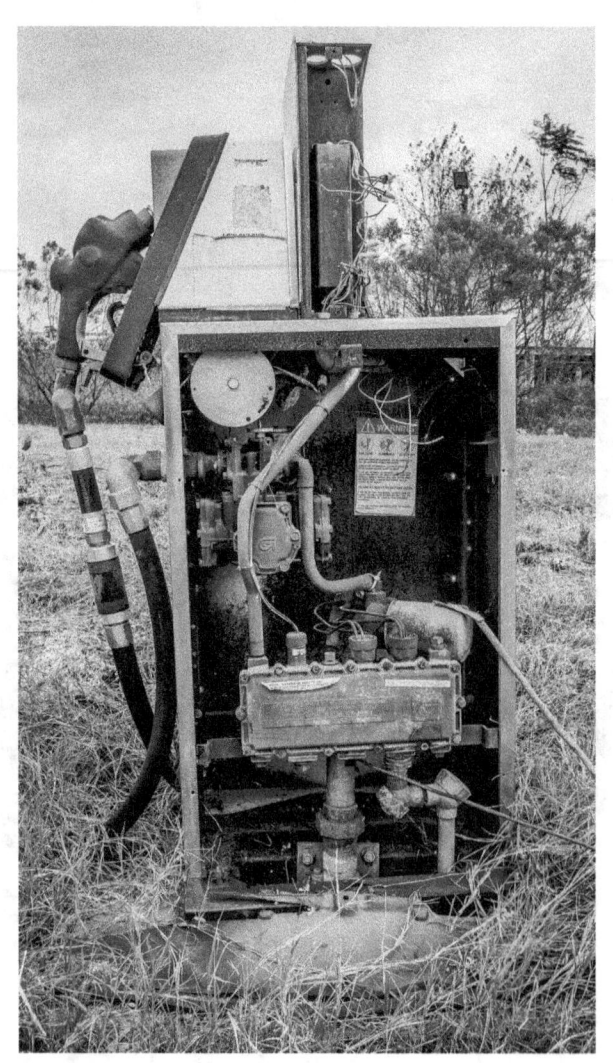

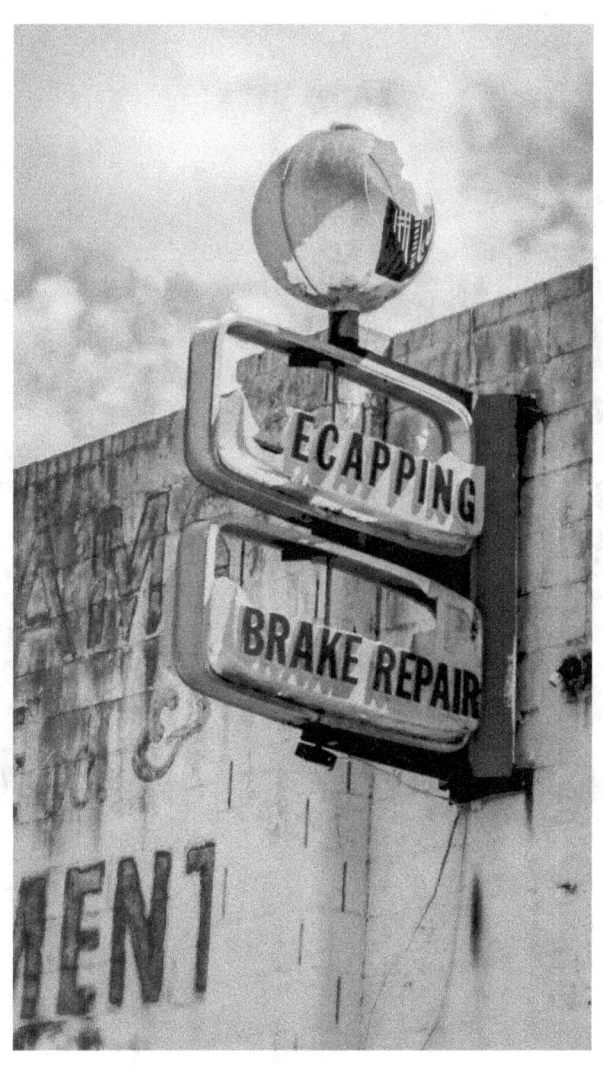

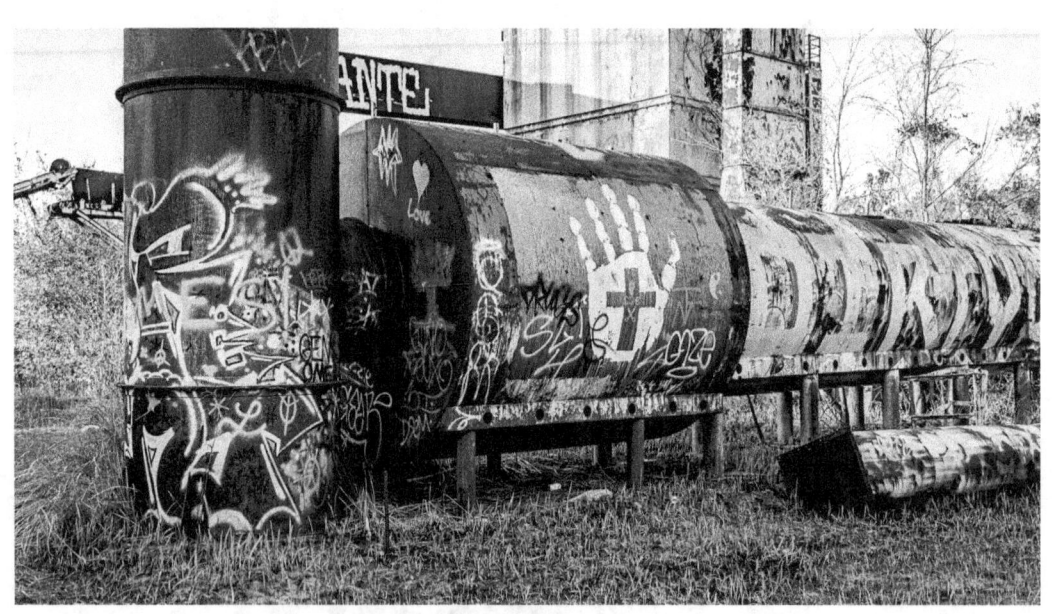

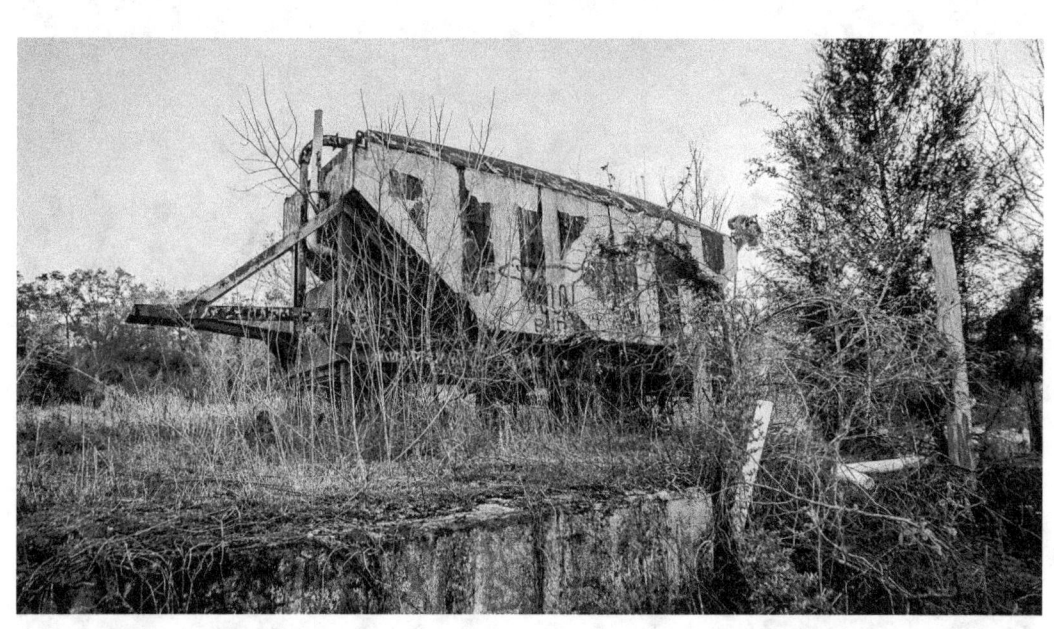

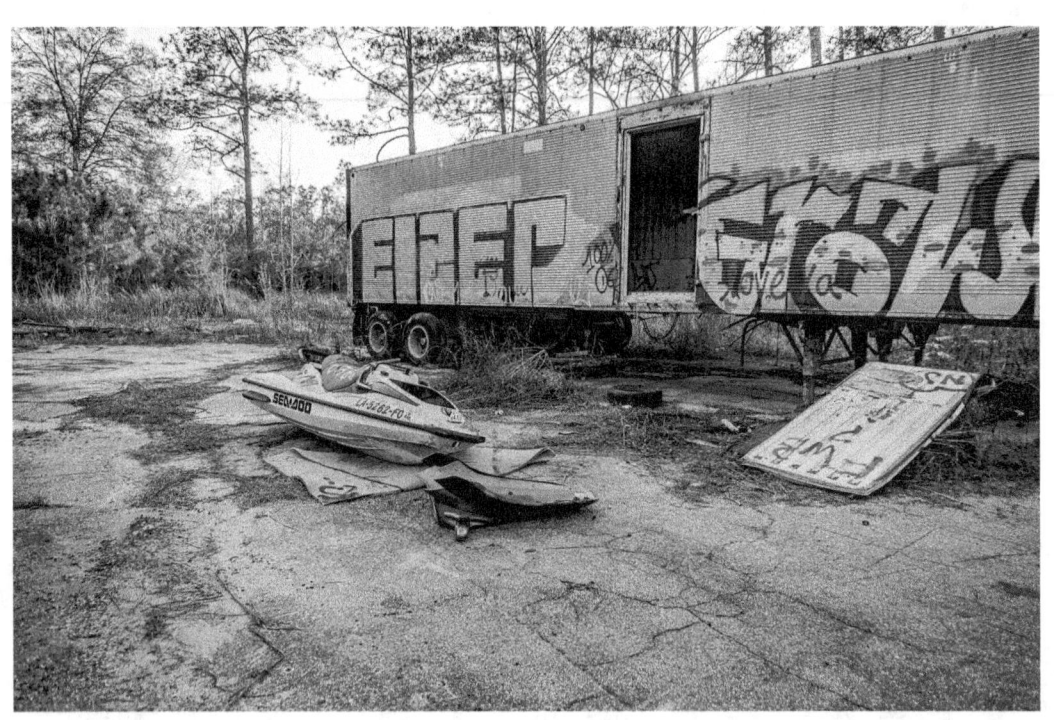

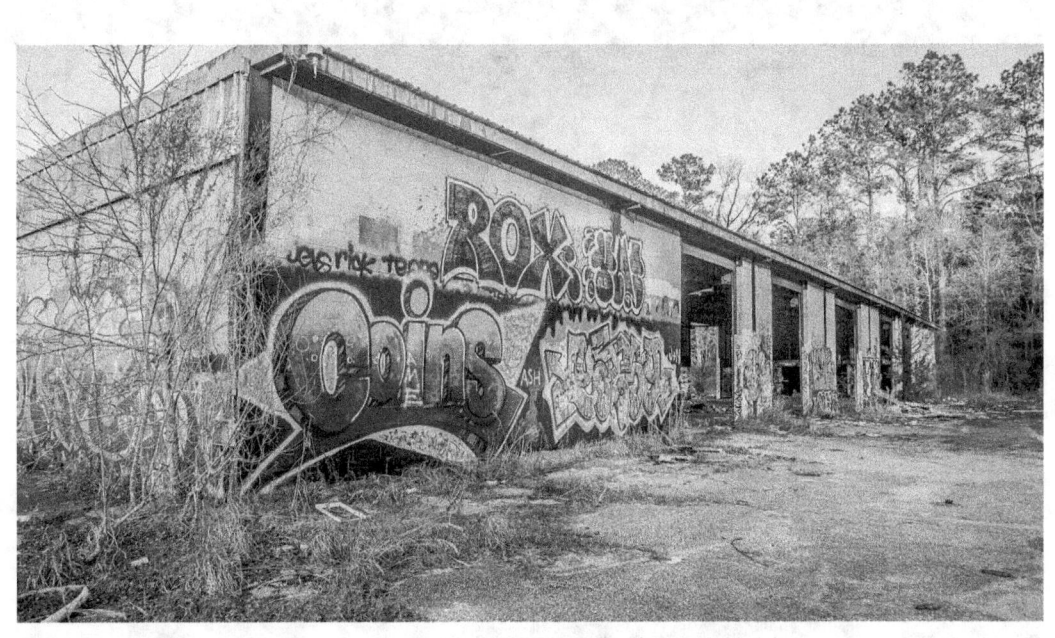

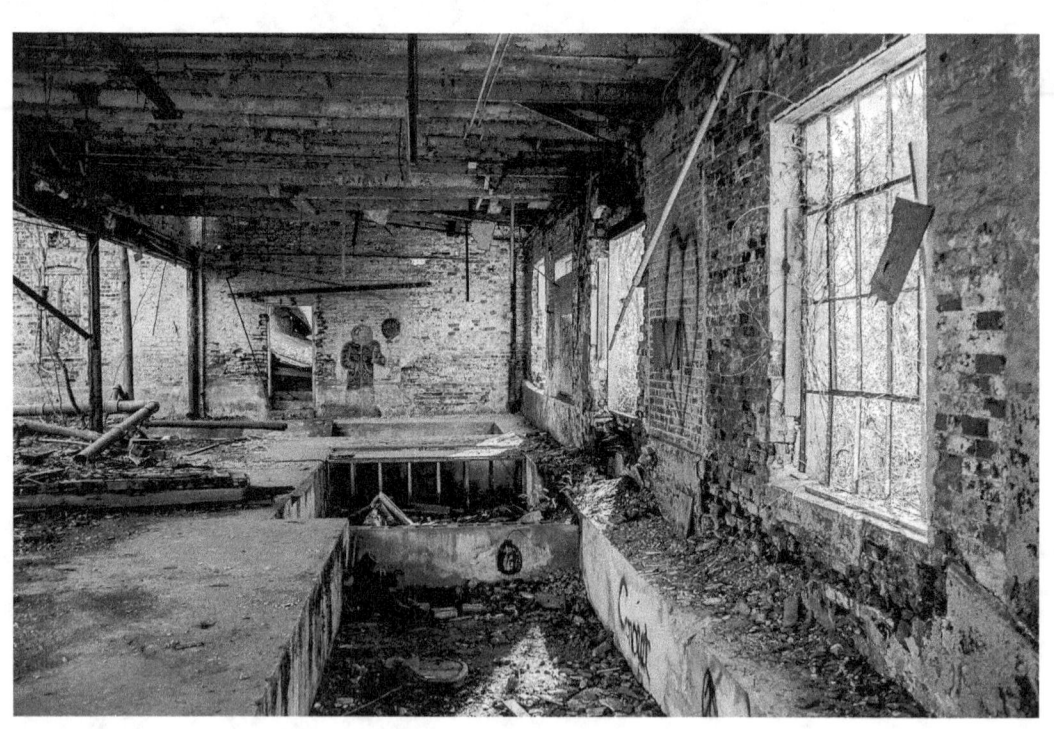

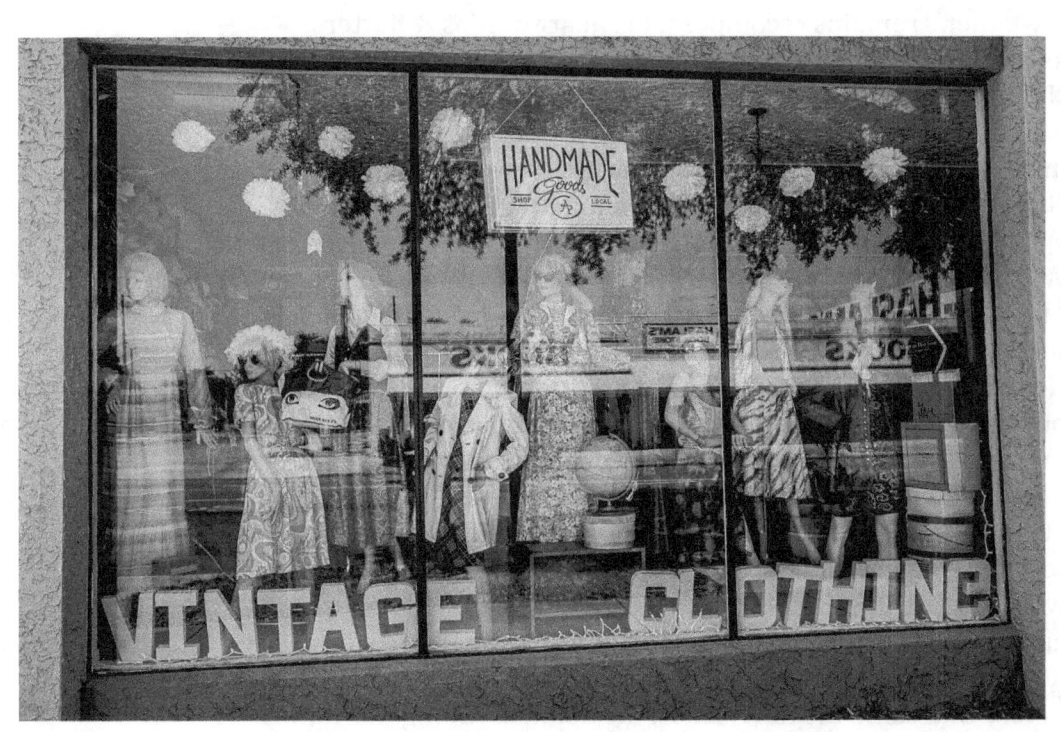

CADAVER EXQUISITO

> "Hangman, hangman, hold it a little while,
> I think I see my friends coming, riding many a mile." –Led Zepellin

The mirrors in the restaurant of exile shattered today.
My father's remains recompose, his heart pumps & flutters
as he joins the dead digging themselves out of countless graves.
No more dancing. No more singing. The streets change
Names. The airplane that brought us propels itself
in reverse, a sky monster choking on its own sooty smoke.
Hazy blood point of perspective diminishing in the distance.
Who fights oblivion to win? Who wants history to absolve them?
We did not belong here, nor will we exist here much longer.
The Magic City crumbles to rubble first, then sand, then dust.
In the straights waves regurgitate the many who drown.
Nobody remembers their names or stories, but they float back
beyond the detritus and flotsam. The asphyxiated walk backward
in camara lenta, long enough for the tropical light to bring back color
to their gaunt faces, and reed-hollowed bodies. The sun counterfits
 its purpose. The island frees itself long enough to enjoy a last cafecito.
In 1962 a man holds his son for the first time, a moist seedling
who will lose itself into a dark and sterile earth. This couple marry
and move to a ravaged city to coil back through impossible
beginnings in 1959--the year a murder of crows ravaged the harvest.
Before that came the hurricanes, the Spanish raping the Tainos.
And even before that the first coconut and the first palm. Lava. Earth.
The sand retreating below the ocean, cooling and burning itself out.
Who were we? What became of us? Those marks we left in the wake
of all this vanishing taking place in another place where the mirrors
are black or covered with stained bed sheets and old rags. Cracked, we
do not recognize ourselves in the cobwebs of that rubble we called home.

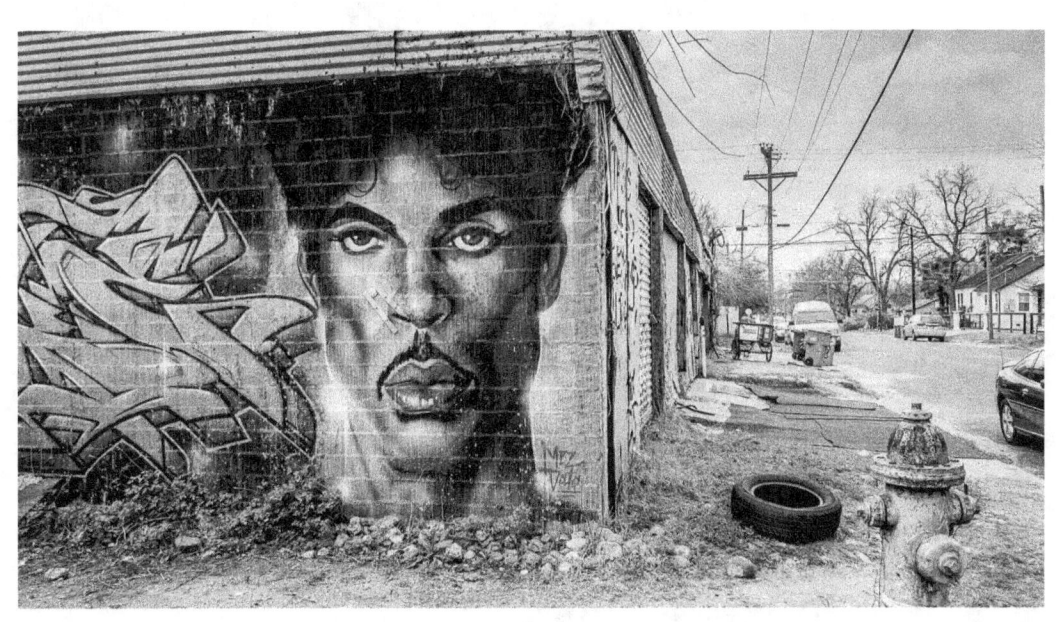

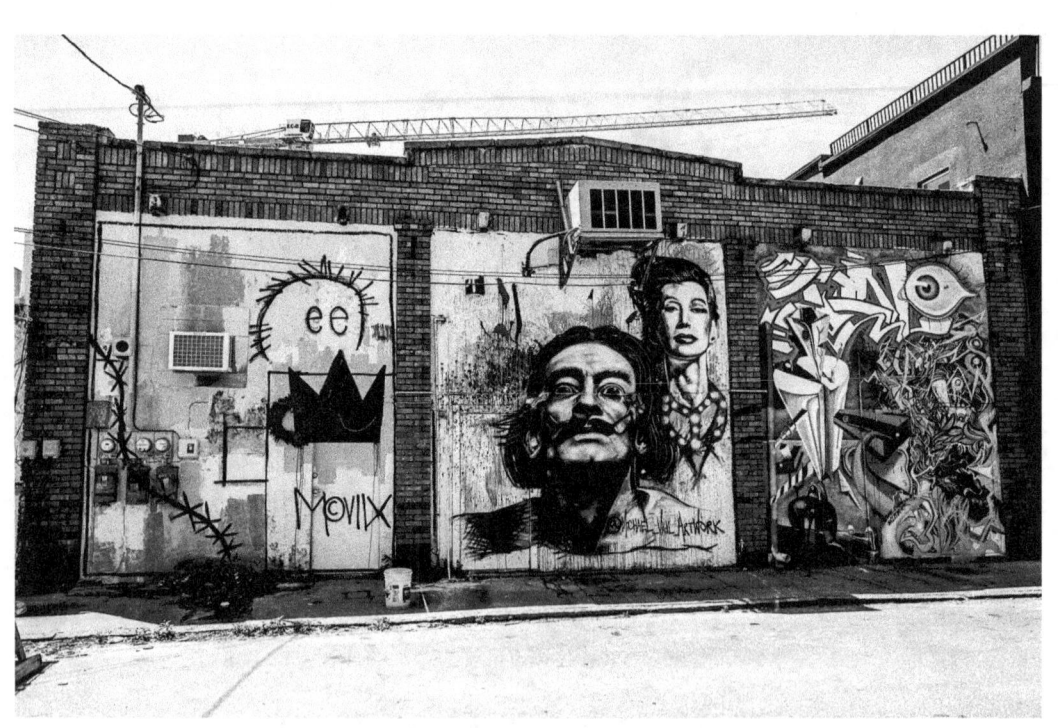

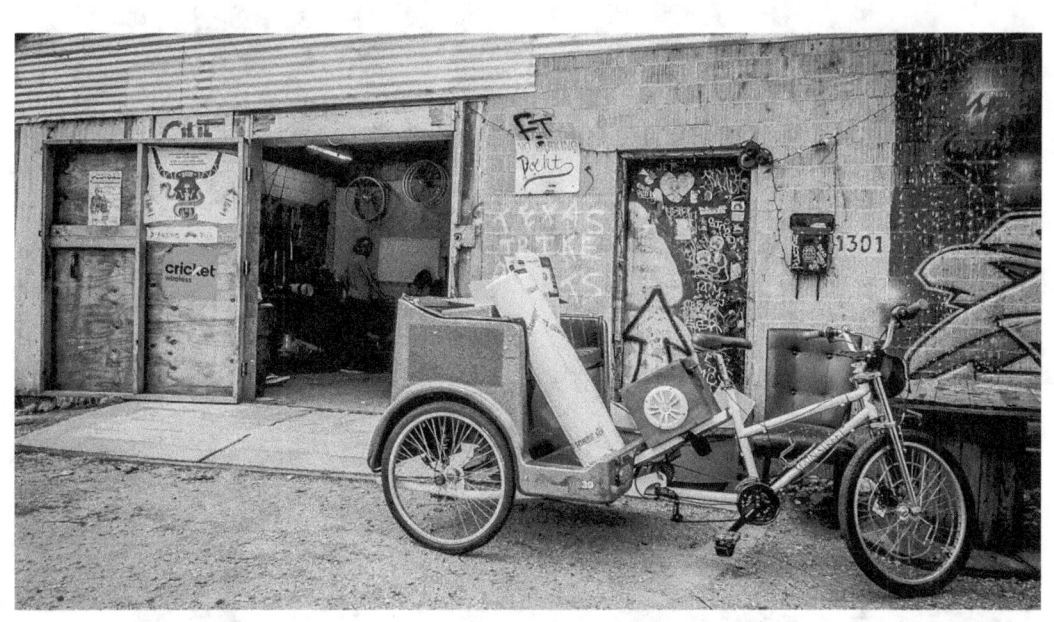

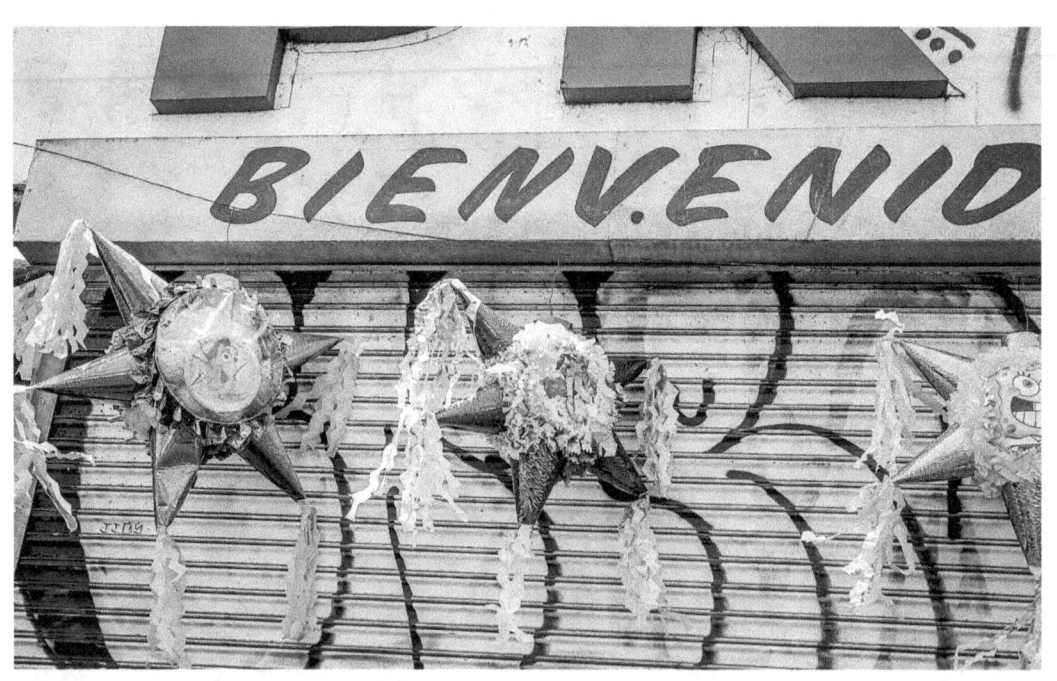

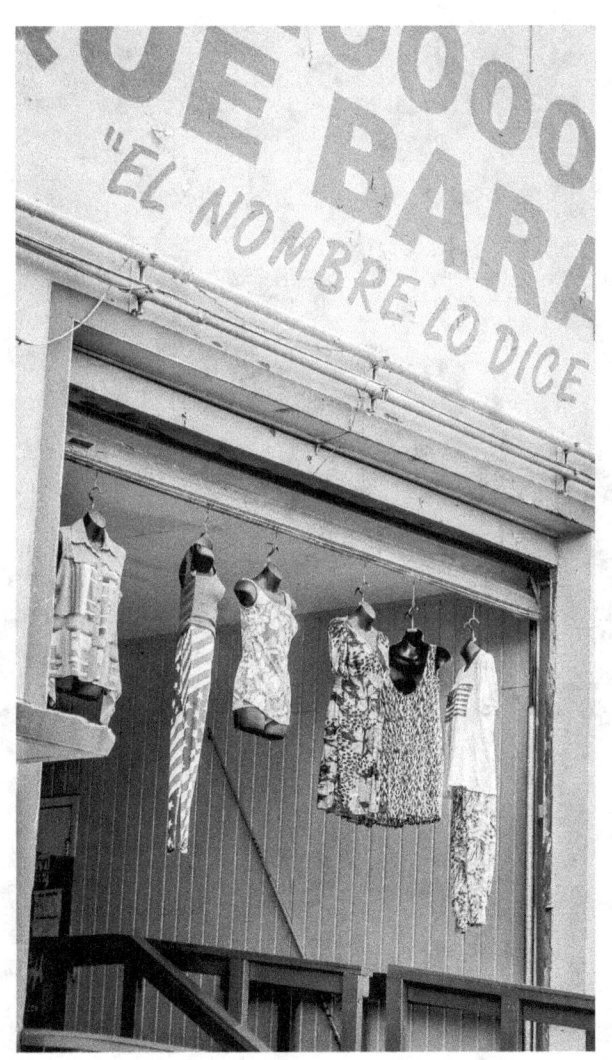

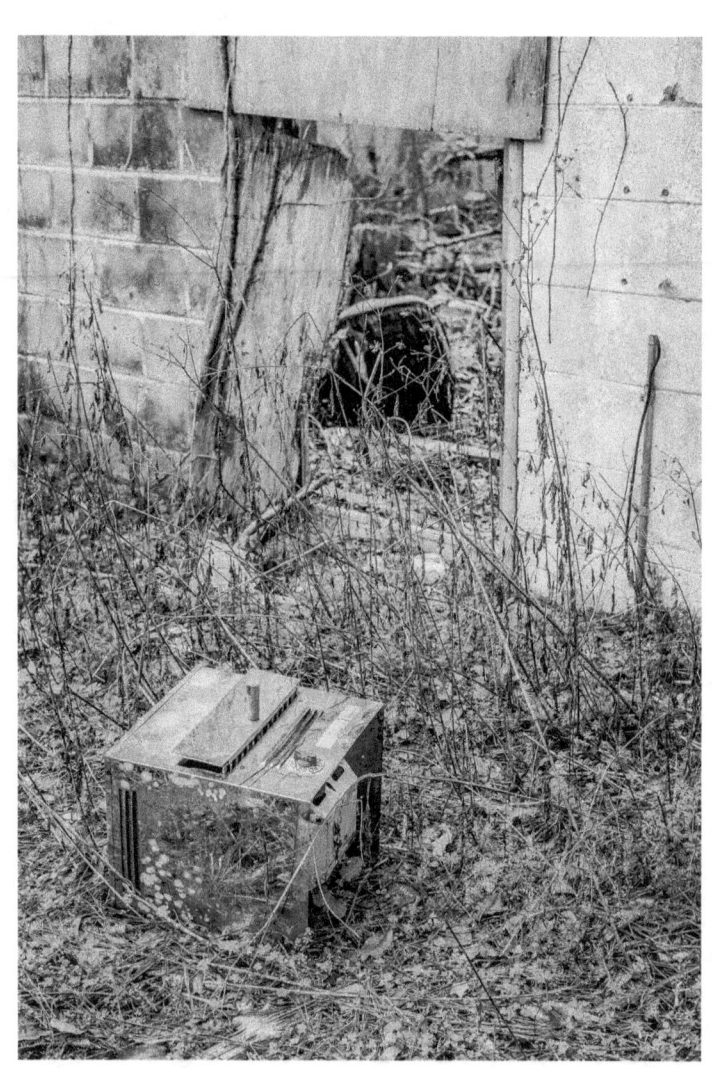

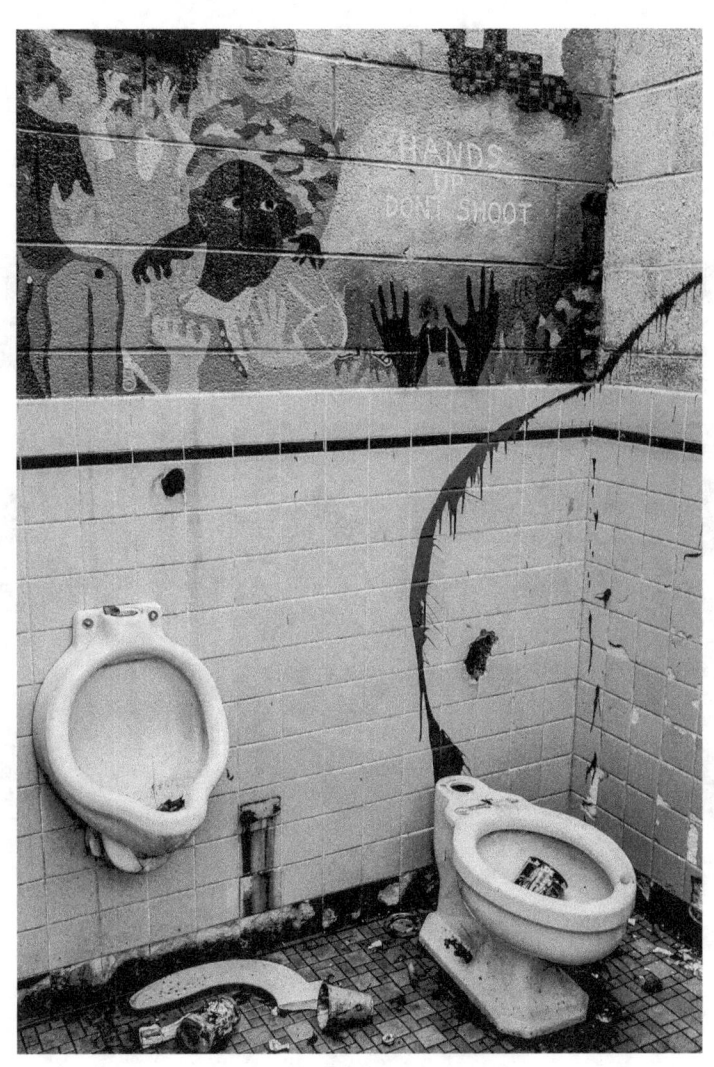

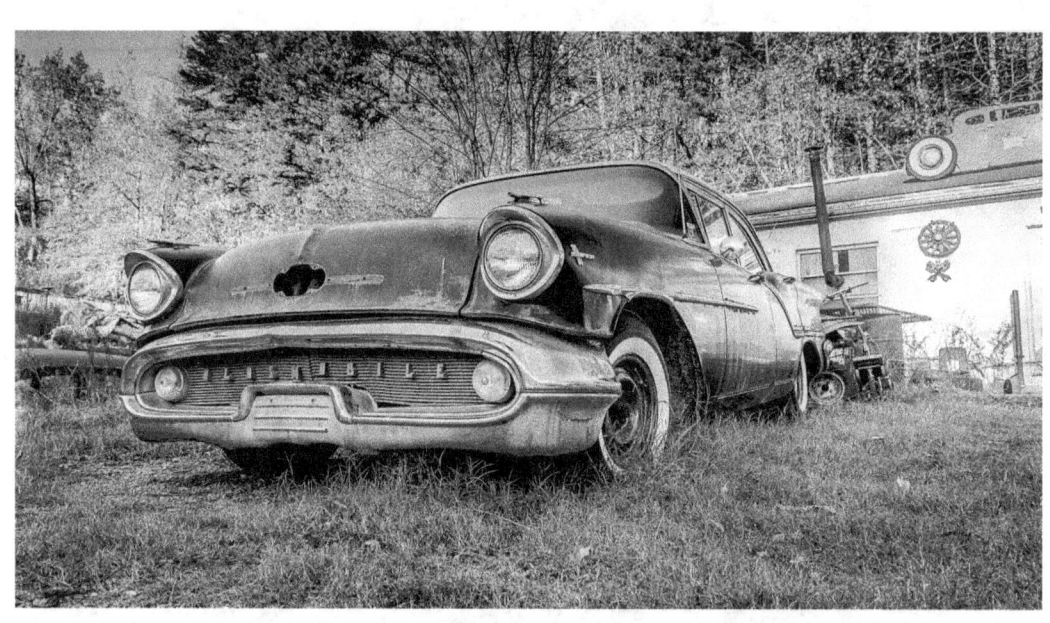

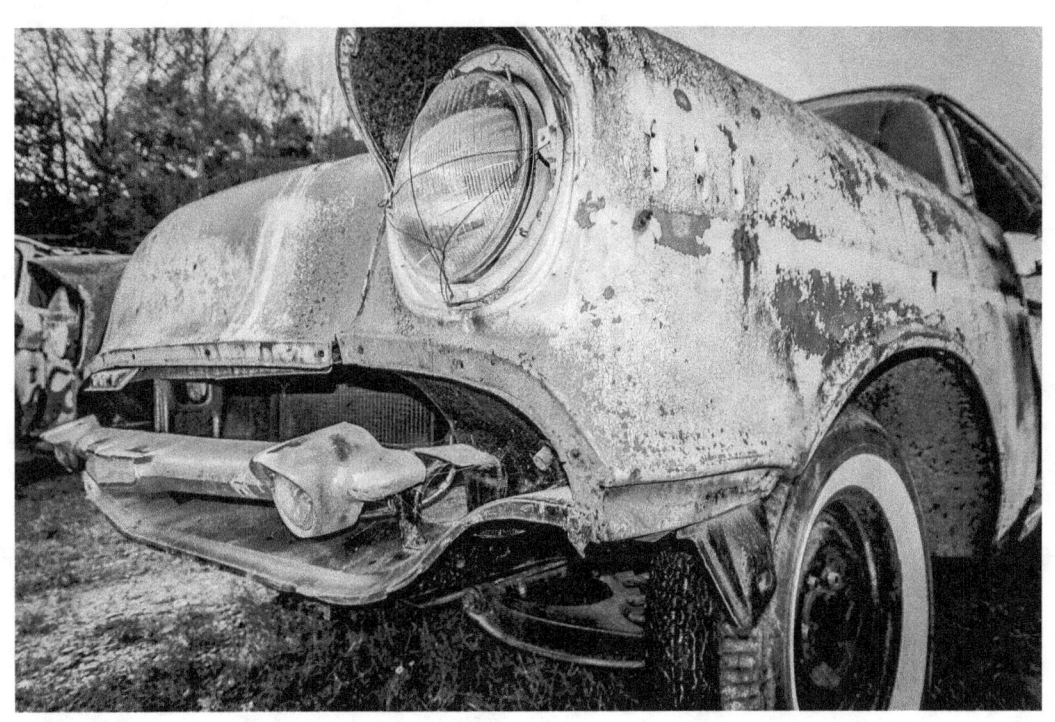

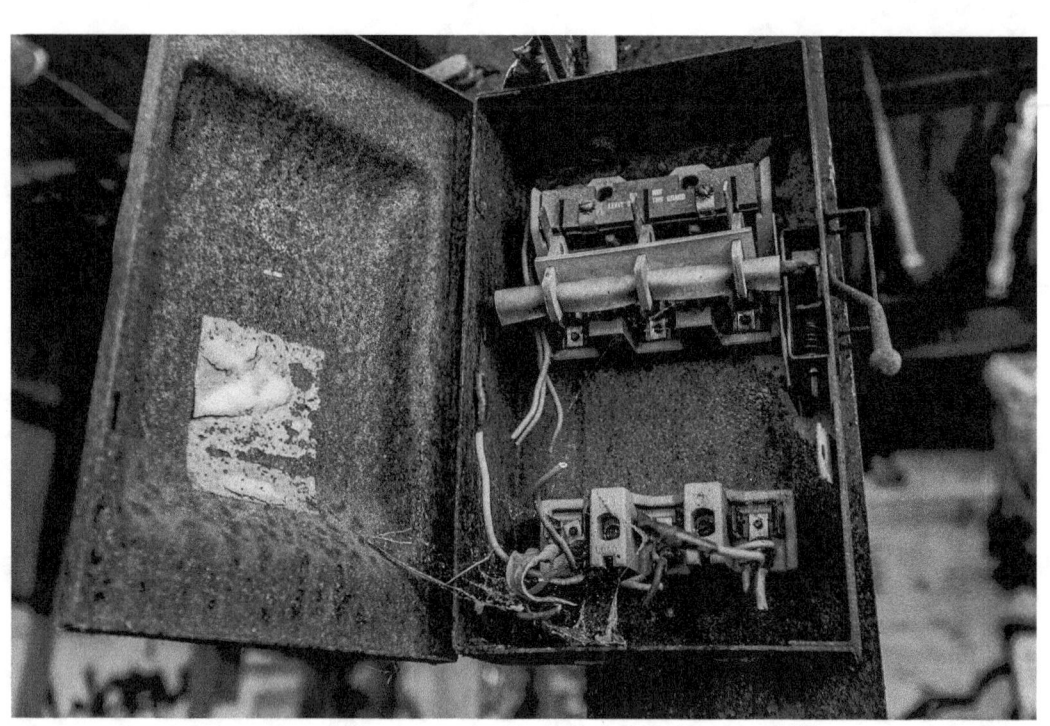

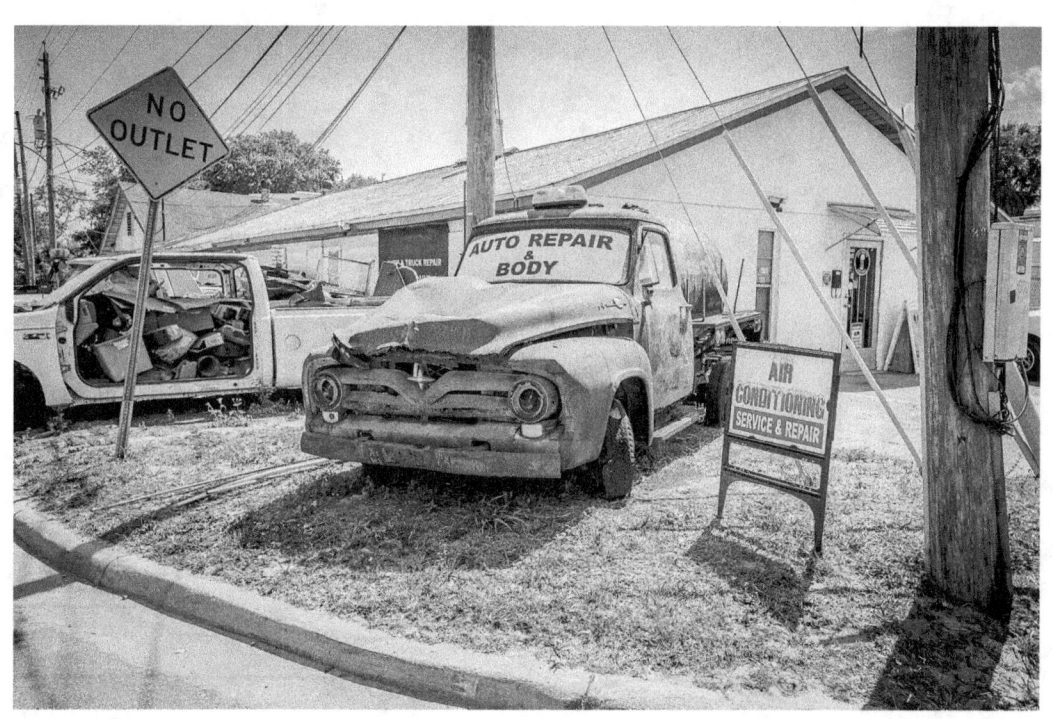

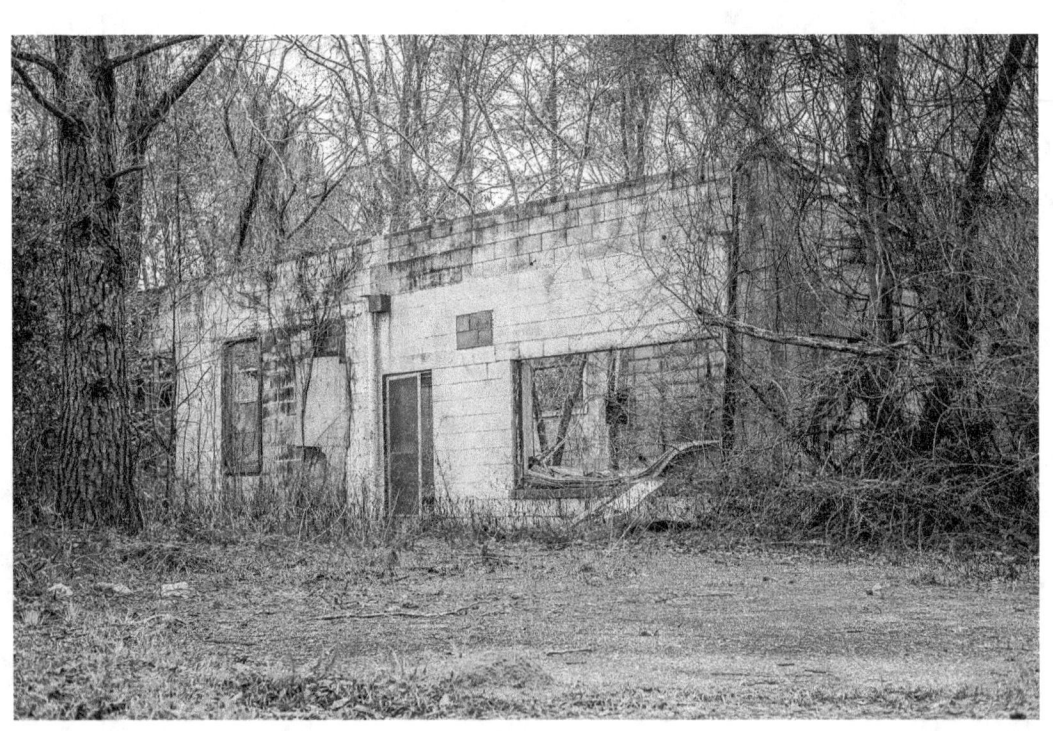

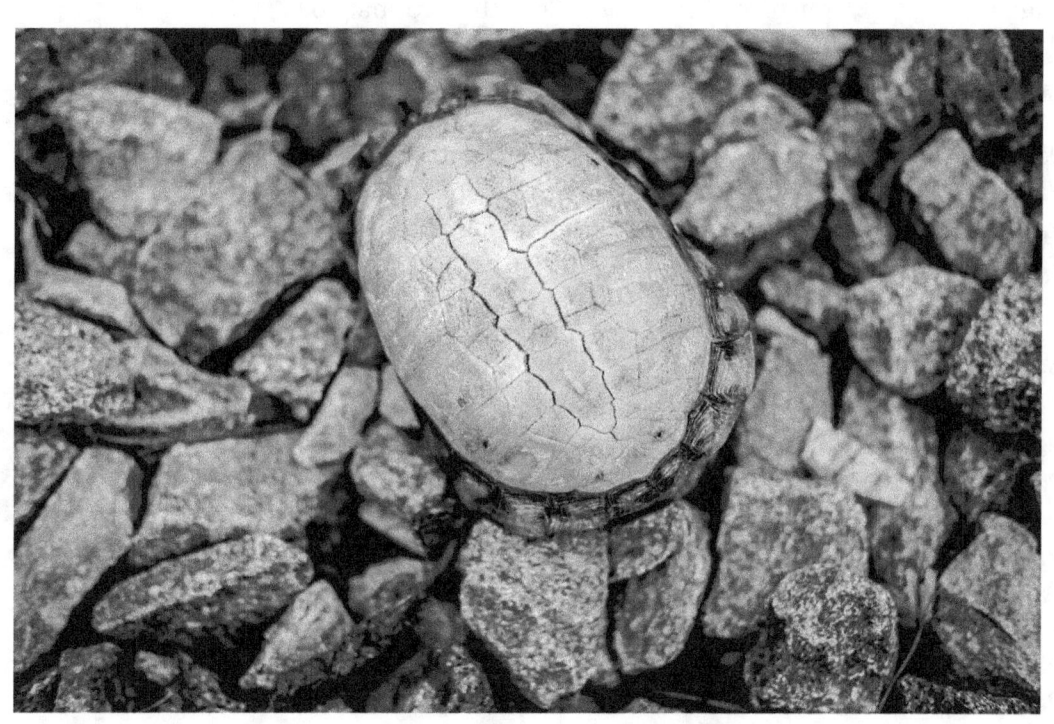

Titles & Notes

Front:	"I Want My MTV," detail, Greensboro, North Carolina, 2017.
Page 1:	"I Want My MTV, Greensboro, North Carolina, 2017.
Page 2:	Theoretical Manifestations.
Page 3:	"Tired," Greensboro, North Carolina, 2017.
Page 4:	"Monsters," Greensboro, North Carolina, 2017.
Page 5:	"Sidetracked Jesus," Greensboro, North Carolina, 2017.
Page 6:	"Out of Gas," Moultrie, Georgia, 2015.
Page 7:	"Abandoned Citgo Diesel," Moultrie, Georgia, 2015.
Page 8:	"Rust & Porcelain," Gibsonville, North Carolina, 2016.
Page 9:	"Penitentiary Royal Flush," Gibsonville, North Carolina, 2016.
Page 10:	"Park Motel," Bradenton, Florida, 2016.
Page 11:	"RV Dreams," Gibsonville, North Carolina, 2017.
Page 12:	"Skeleton in Window," Austin, Texas, 2018.
Page 13:	"Clown Doll," Little Havana, Florida, 2014.
Page 14:	"The Beautiful Light," a poem published in Miramar Review, 2017.
Page 15:	"Lulu's Laboratorium," Wynwood, Miami, Florida, 2018.
Page 16:	"Why is Talbott Smiling?" St. Petersburg, Florida, 2017.
Page 17:	"Pumped," Thomasville, Georgia, 2014.
Page 18:	"Brake Repair," Valdosta, Georgia, 2015.
Page 19:	"The Virgin Blesses Mercurio," Merida, Mexico, 2017.
Page 20:	"Dirty White Hands," Blounstown, Florida, 2016.
Page 21:	"Dirty Car," Blounstown, Florida, 2016.
Page 22:	"SeaDoo," Blounstown, Florida, 2016.
Page 23:	"Ash Coins," Blounstown, Florida, 2016.
Page 24:	"Between Balloons and Bombs," Bellemont, North Carolina, 2017.
Page 25:	"Handmade Vintage Clothing," Tampa, Florida, 2016.
Page 26:	"Cadaver Exquisito," unpublished poem, 2018.
Page 27:	"Prince Mural," Austin, Texas, 2017.
Page 28:	"Dali is Watching Everything," Austin, Texas, 2017.
Page 29:	"Texas Trikes," Austin, Texas, 2018.

Titles & Notes Continued

Page 30:	"Piñatas," Los Angeles, California, 2018.
Page 31:	"Ño, Que Barato: El Nombre Lo Dice Todo," Miami, Florida, 2018.
Page 32:	"Big Ed's Oldsmobile," North Carolina, 2017.
Page 33:	"Bumperless 56 Chevy," North Carolina, 2017.
Page 34:	"Infra-Chef," Chiefland, Florida, 2013.
Page 35:	"Hands Up/Don't Shoot," Greensboro, North Carolina, 2016.
Page 36:	"Thrown," Bellemont, North Carolina, 2017.
Page 37:	"Auto Repair," Tampa, Florida, 2018.
Page 38:	"We Lived Here," Chiefland, Florida, 2013.
Page 39:	"What We Left Behind," Gibsonville, North Carolina, 2017.
Page 40:	Titles & Notes.
Page 41:	Titles & Notes Continued.
Page 42:	About the Author.
Back Cover:	Author photo courtesy of Mr. Carlton Temple, Greensboro, North Carolina, 2017.

Virgil Suárez was born in Havana, Cuba in 1962. At the age of twelve he arrived in the United States. He received an MFA from Louisiana State University in 1987. He is the author of eight collections of poetry, most recently 90 MILES: SELECTED AND NEW published by the University of Pittsburgh Press. His work has appeared in a multitude of magazines and journals internationally. When he is not writing, he is out riding his motorcycle up and down the Blue Highways of the Southeast, photographing disappearing urban and rural landscapes.

www.ingramcontent.com/pod-product-compliance
Lightning Source LLC
Chambersburg PA
CBHW081645220526
45468CB00009B/2564